COLOURING BOOK BY

Polly Jenkins

Facebook.com/PollyJenkinsPublishing

@pollyjenkinspublishing

No part of this book may be reproduced, transmitted or distributed by any means without permission from the publisher.

For questions and customer service, email us at: Jenkinspolly@outlook.com

TEST PAGE

- THE PAGES IN OUR BOOKS CAN STAND UP TO MOST PENS AND MARKERS BUT SOME WATER BASED PRODUCTS MAY GO THROUGH.
- TEST YOUR DIFFERENT COLOURING TOOLS HERE BEFORE LETTING LOOSE ON YOUR NEW BOOK:

TEST THE PAGE BLEED HERE:

TEST YOUR COLOUR COMBINATIONS HERE:

HANDY TIP: WHY NOT PUT A PIECE OF CARD BEHIND THE PAGE YOU ARE COLOURING JUST TO BE SURE NO LITTLE BLOTCHES GO THROUGH

REVERSE OF MEDIA TEST PAGE

- CHECK FOR POSSIBLE BLEED THROUGH THE PAGE BEFORE STARTING ON YOUR NEW BOOK.

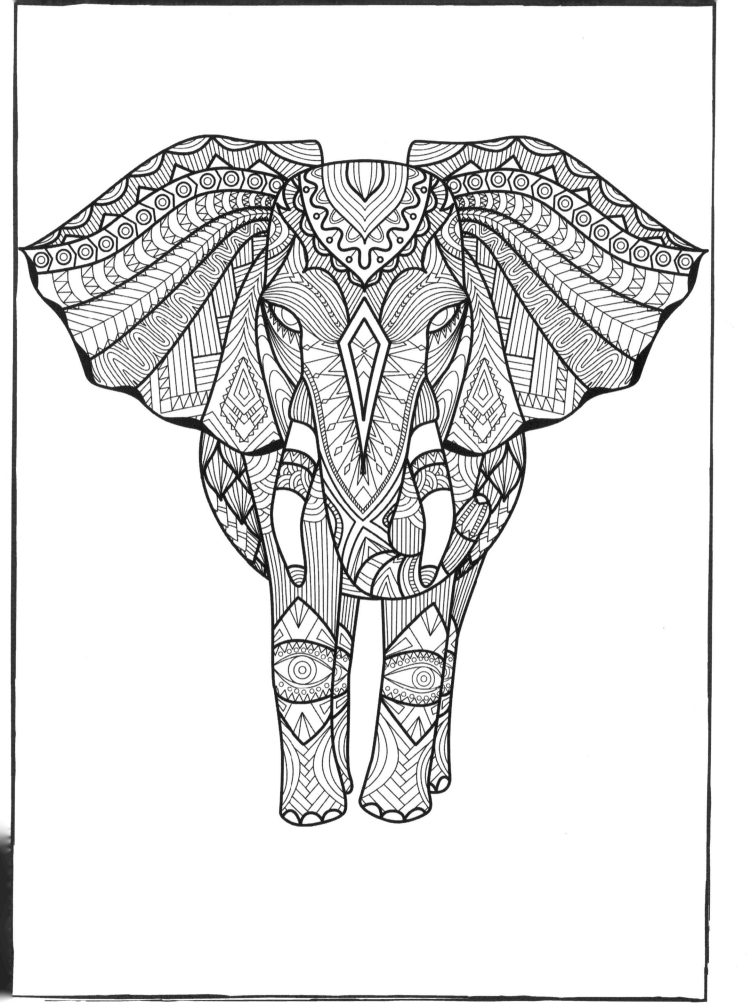

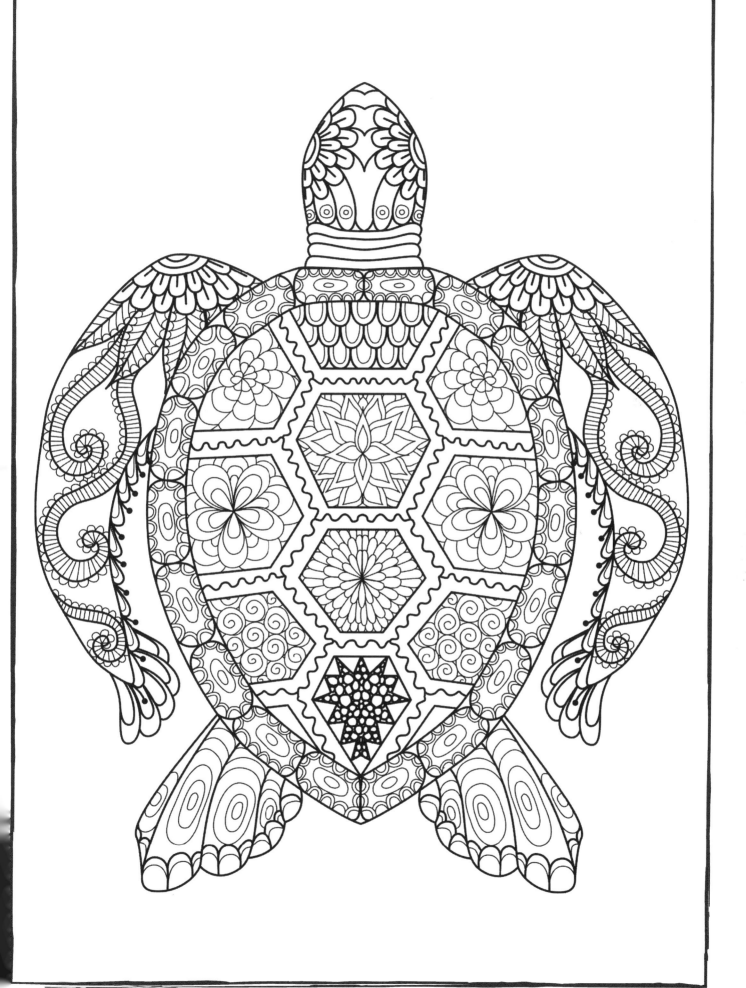

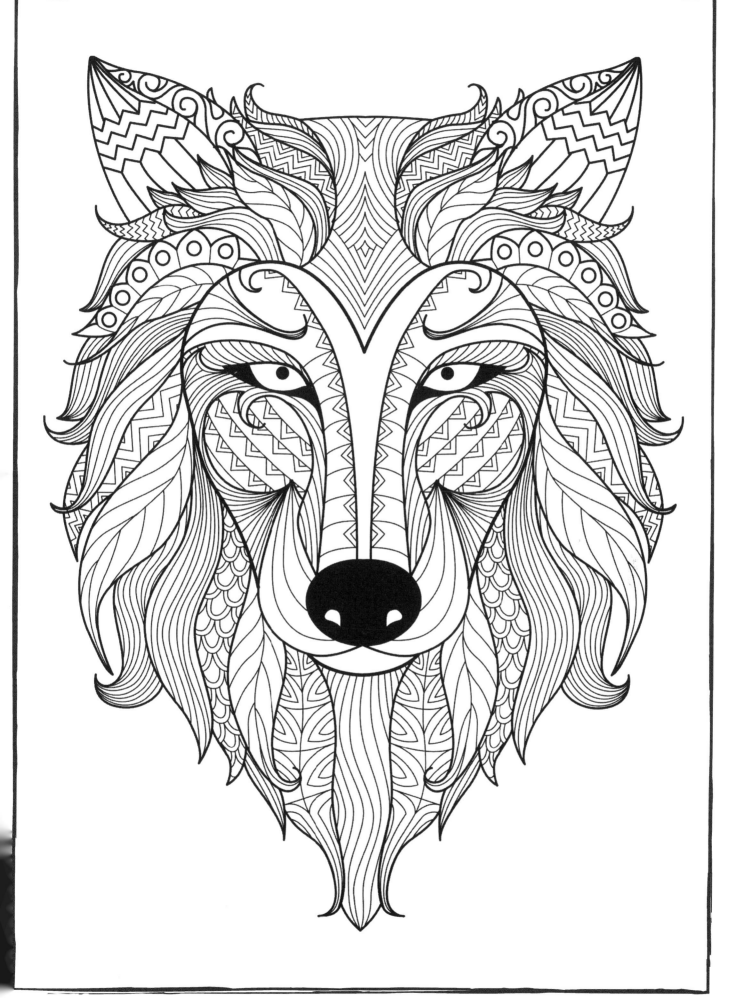

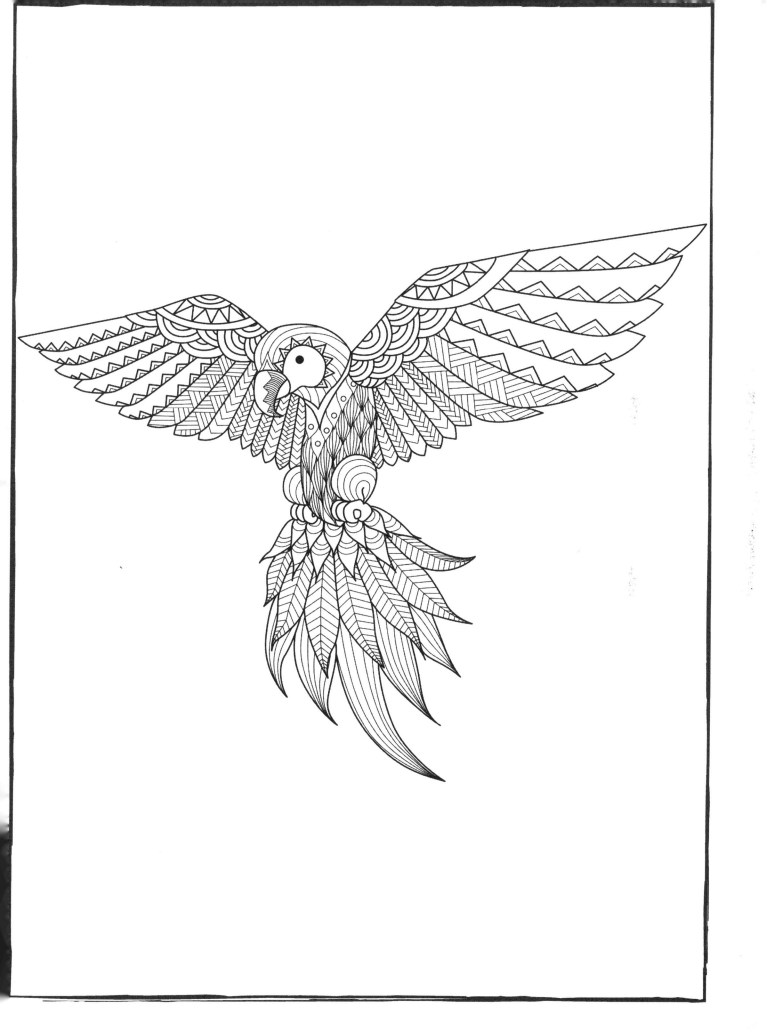

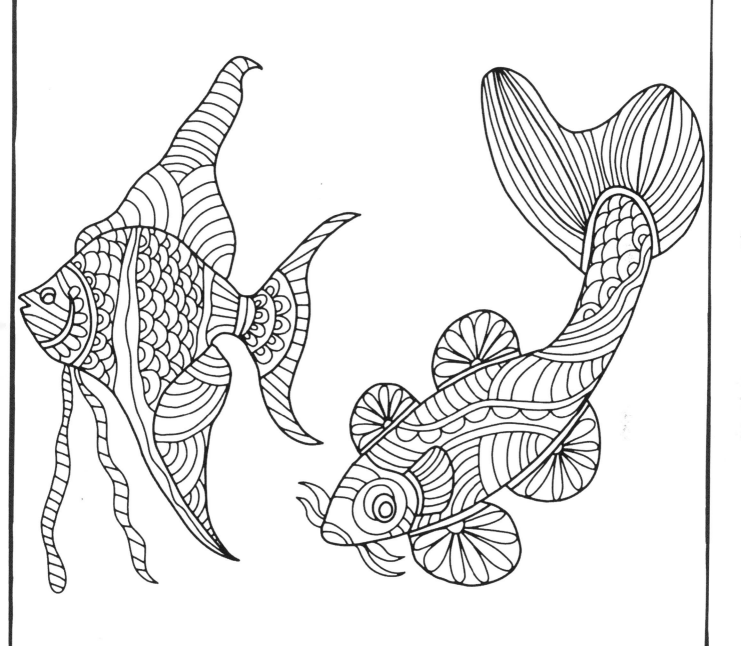

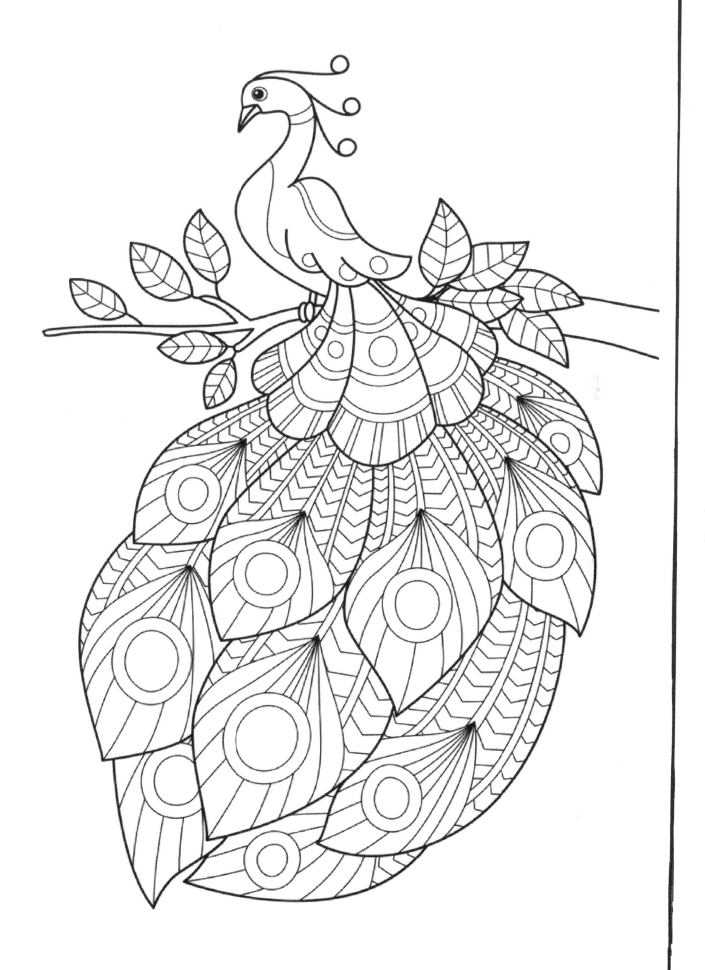

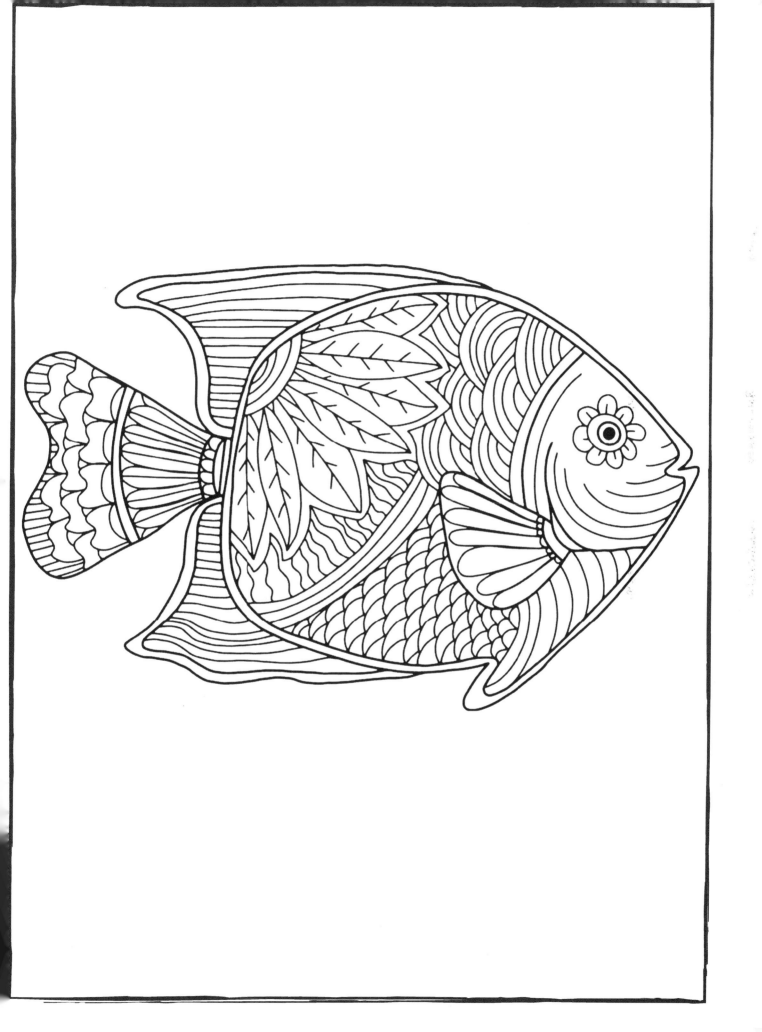

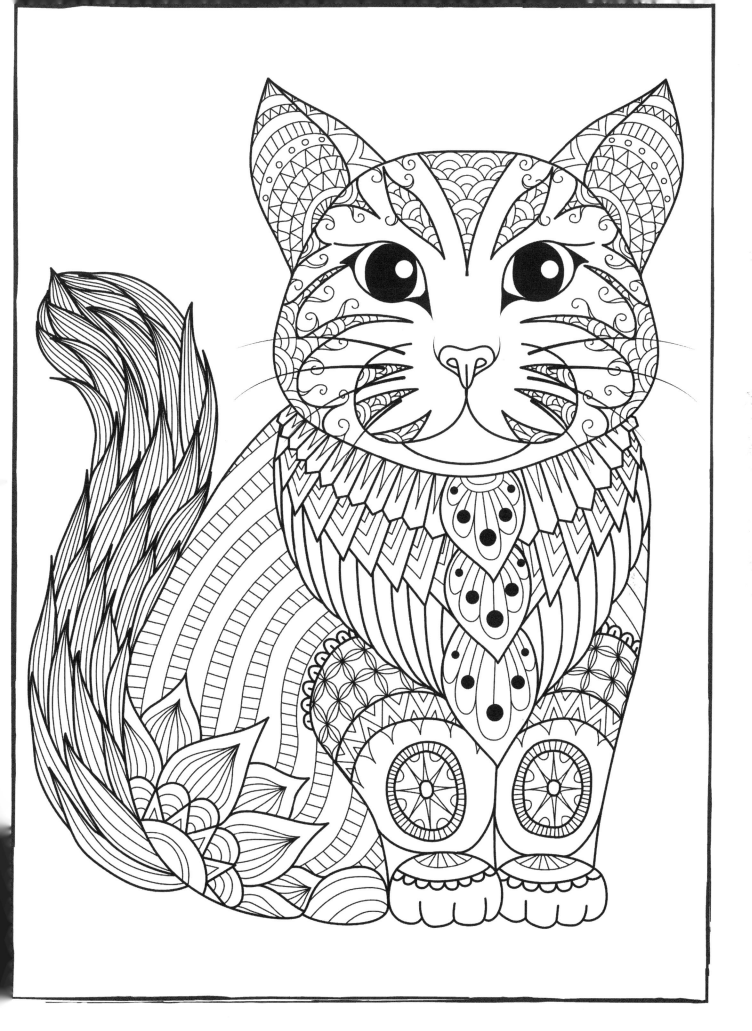

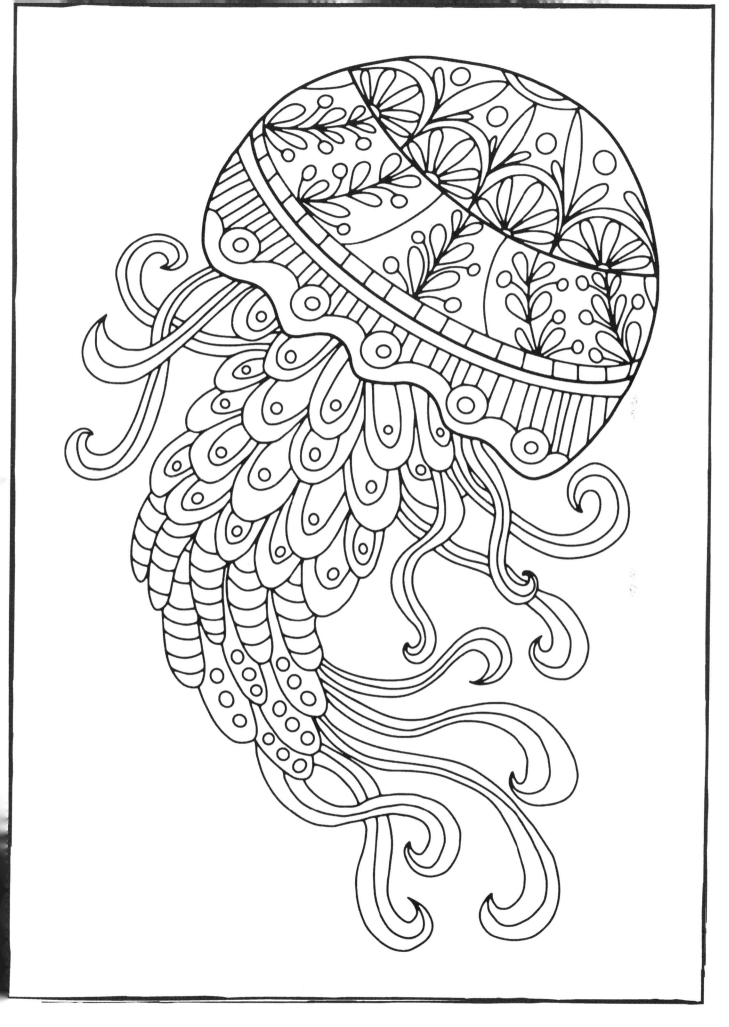

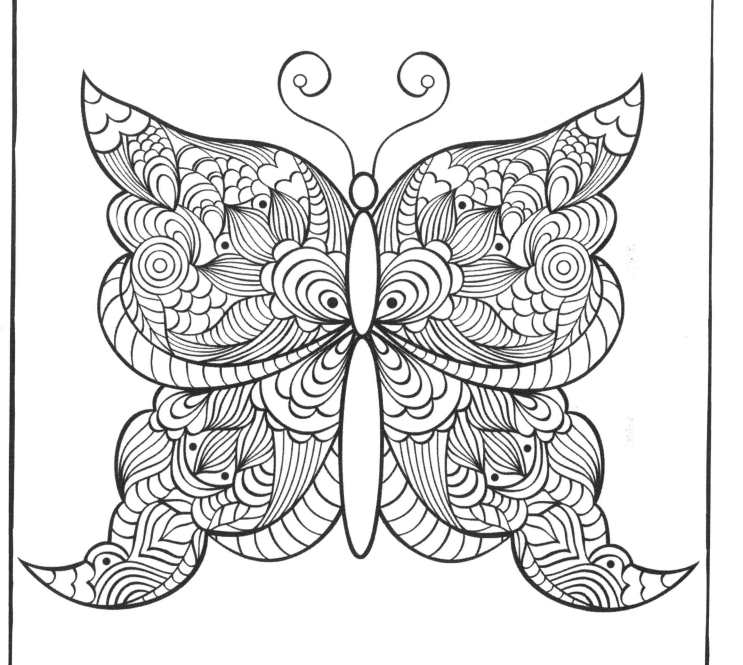

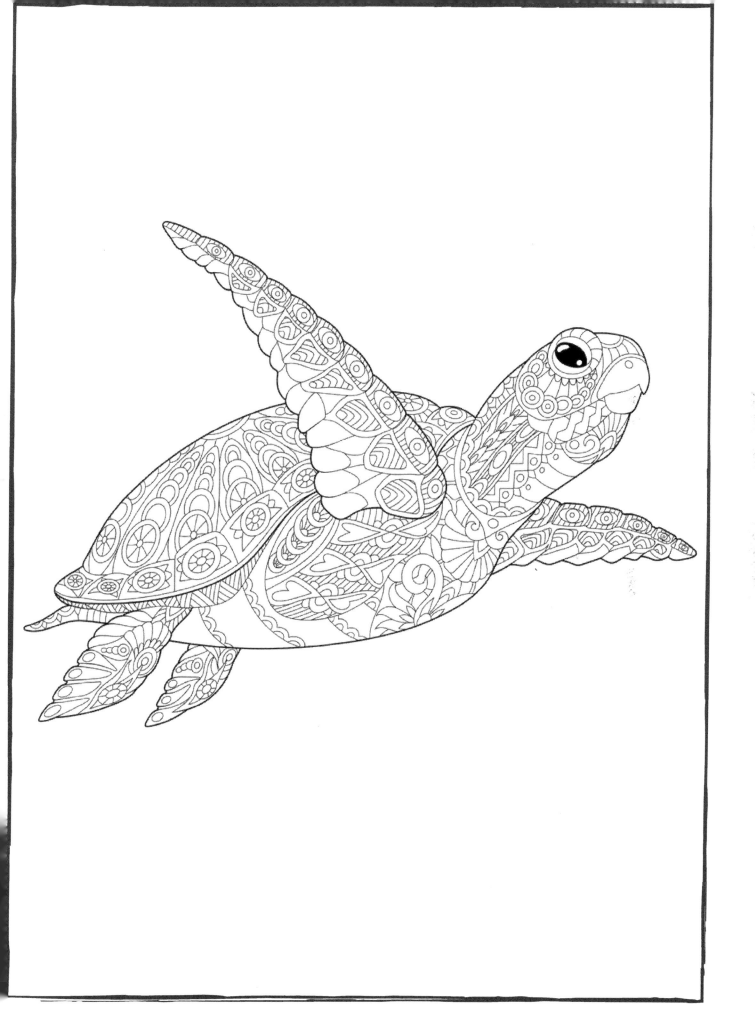

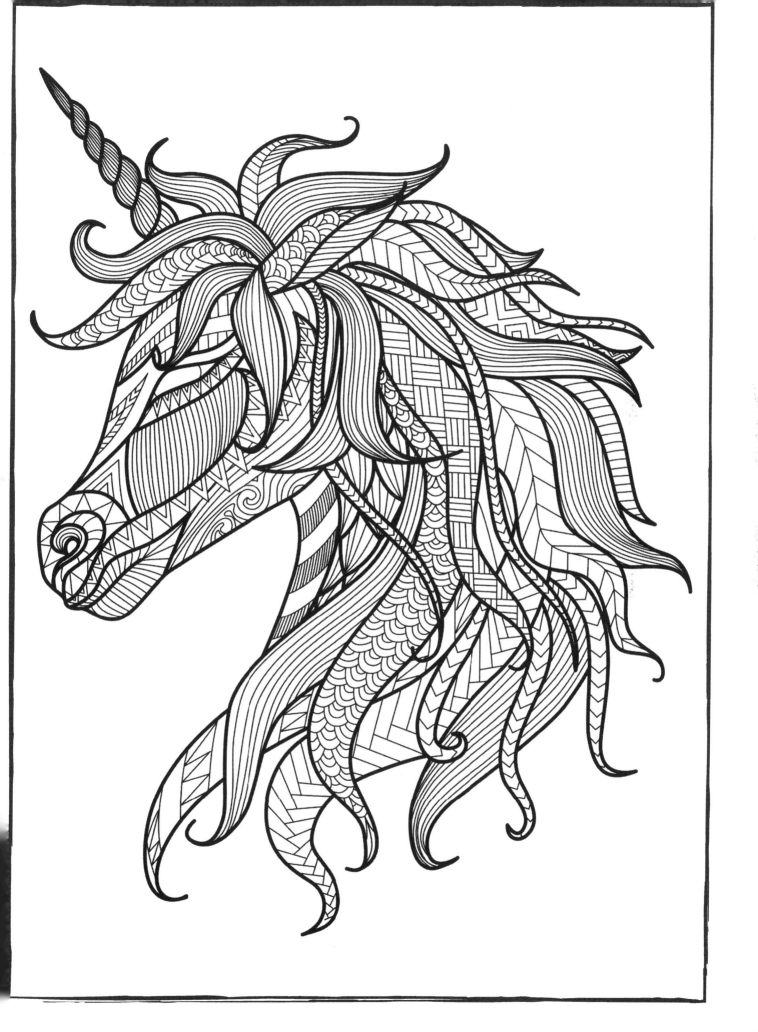

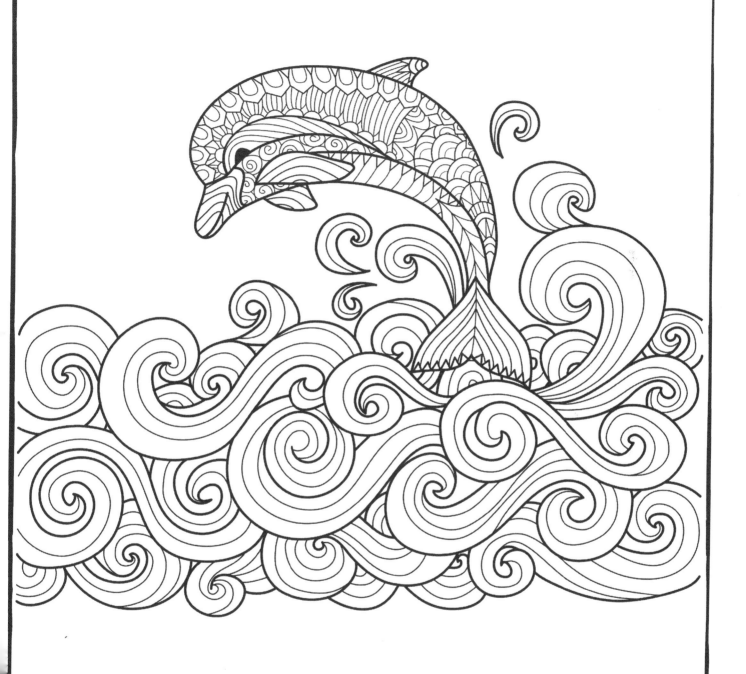

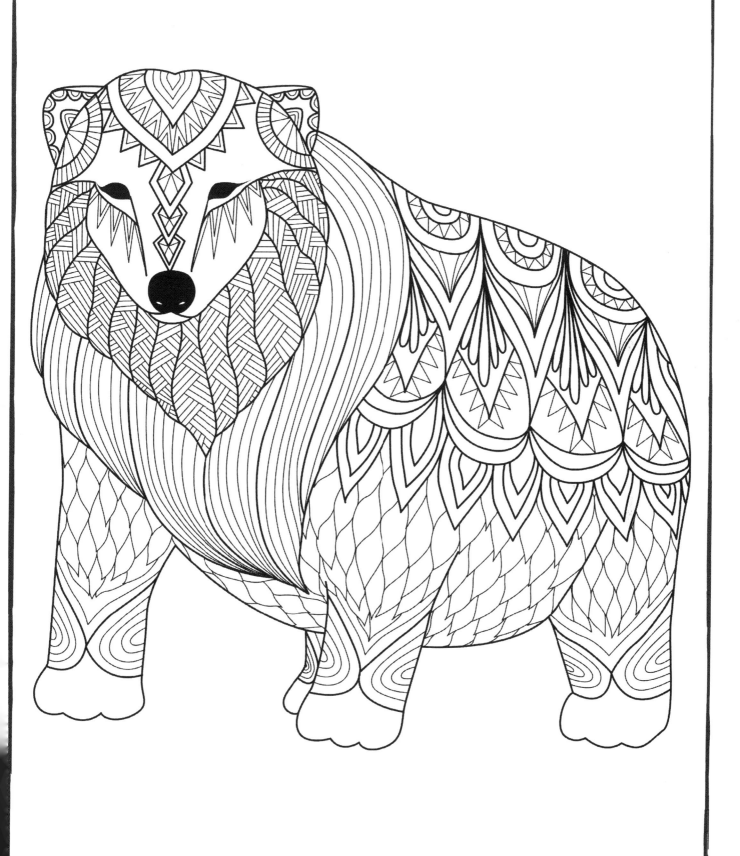

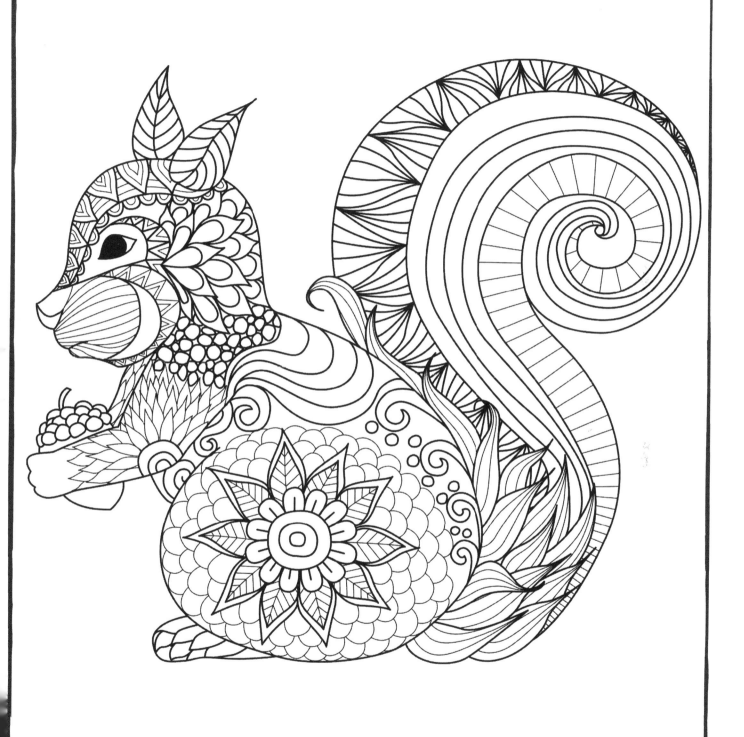

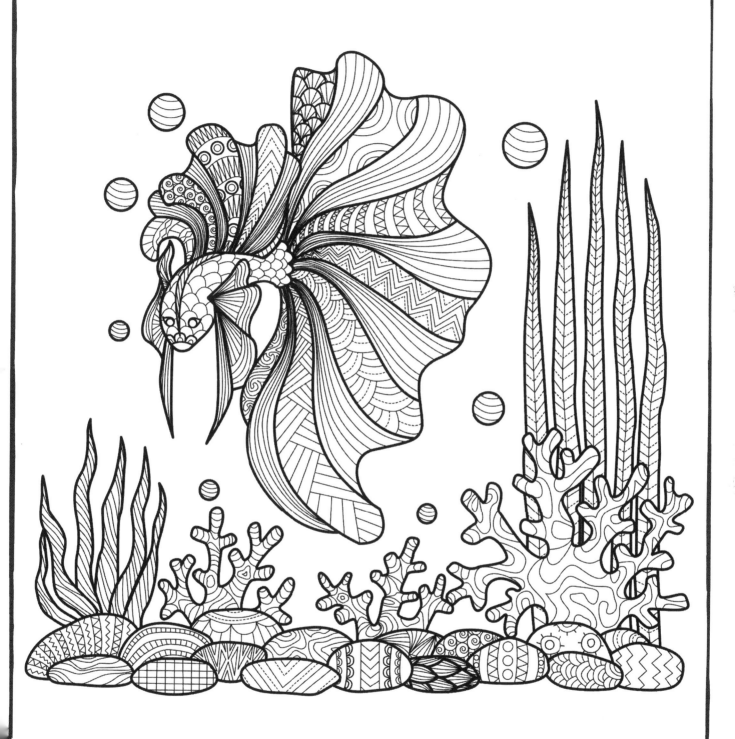

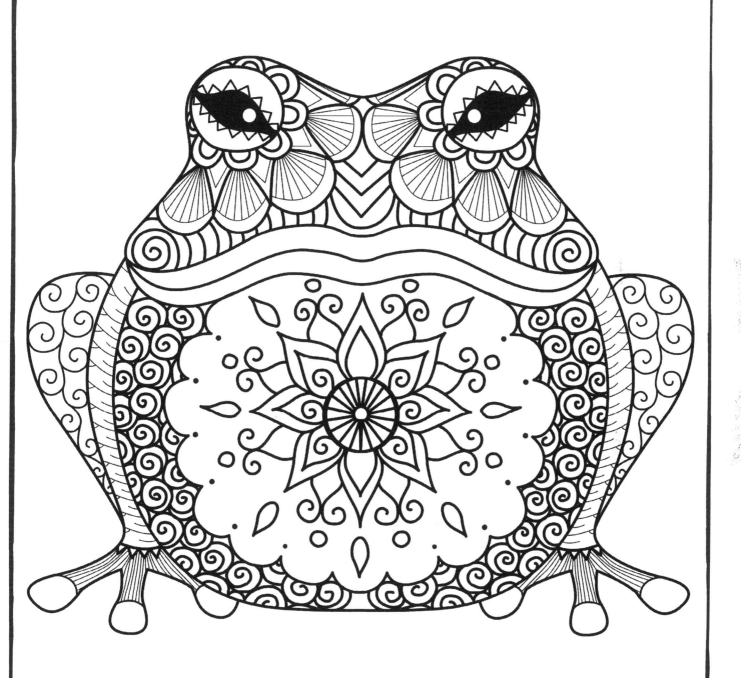

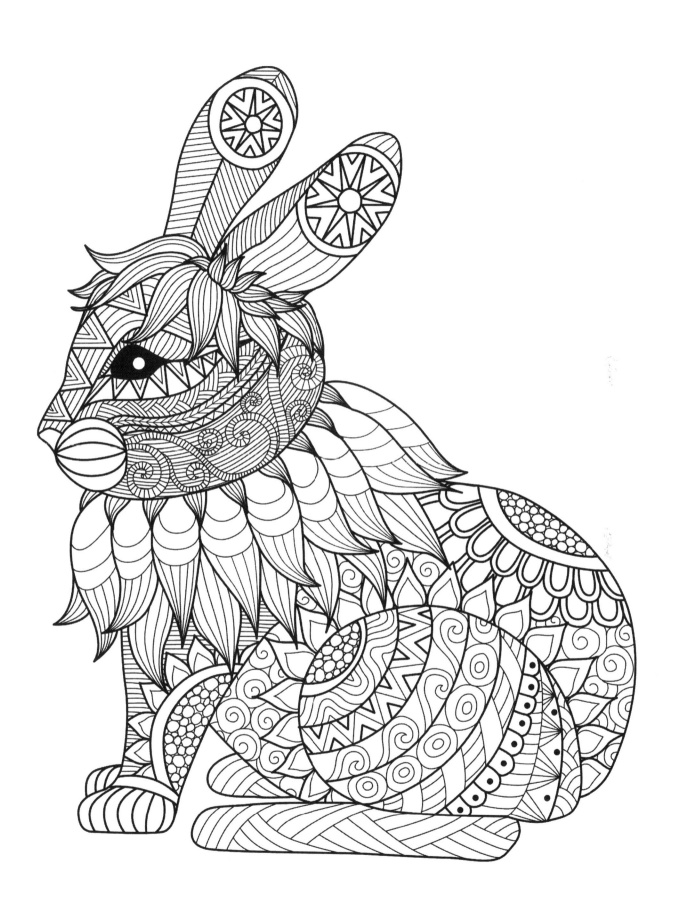

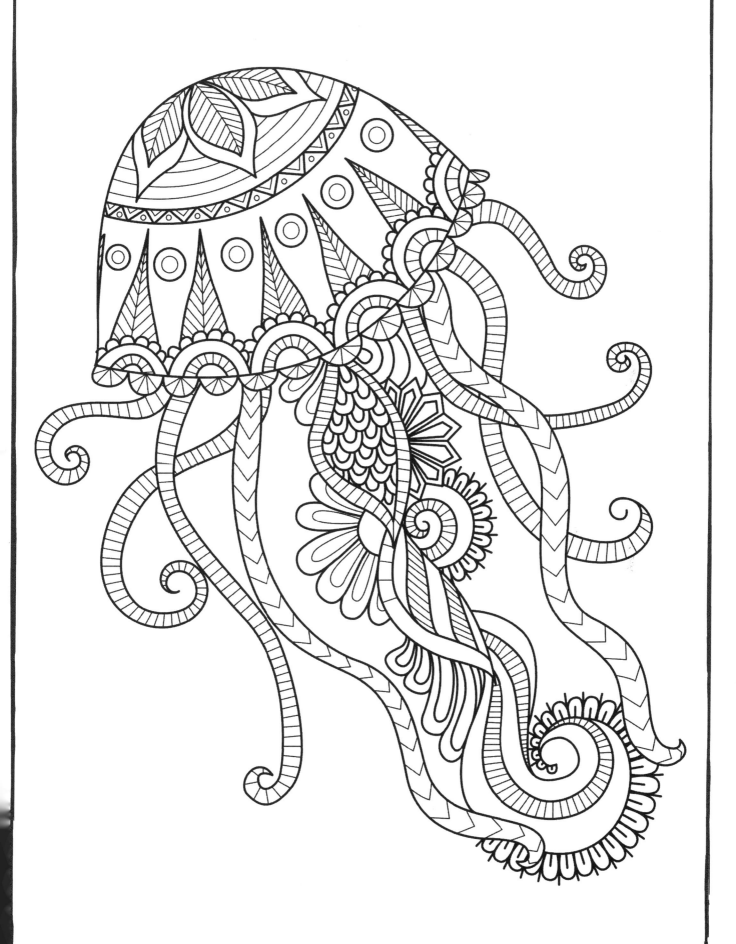

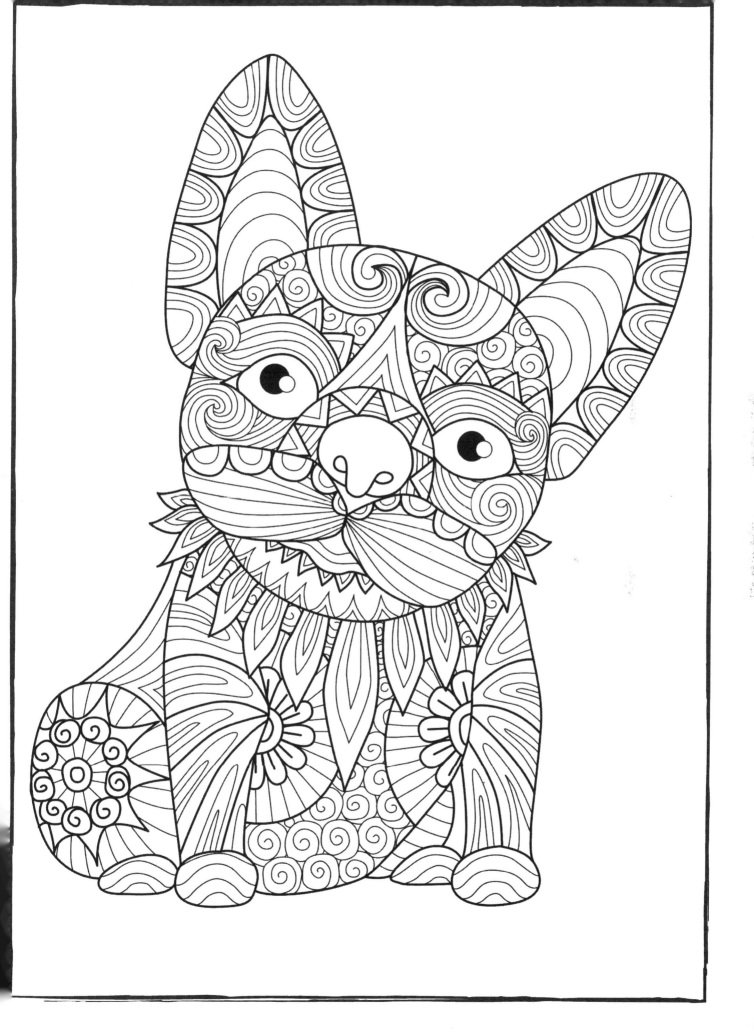

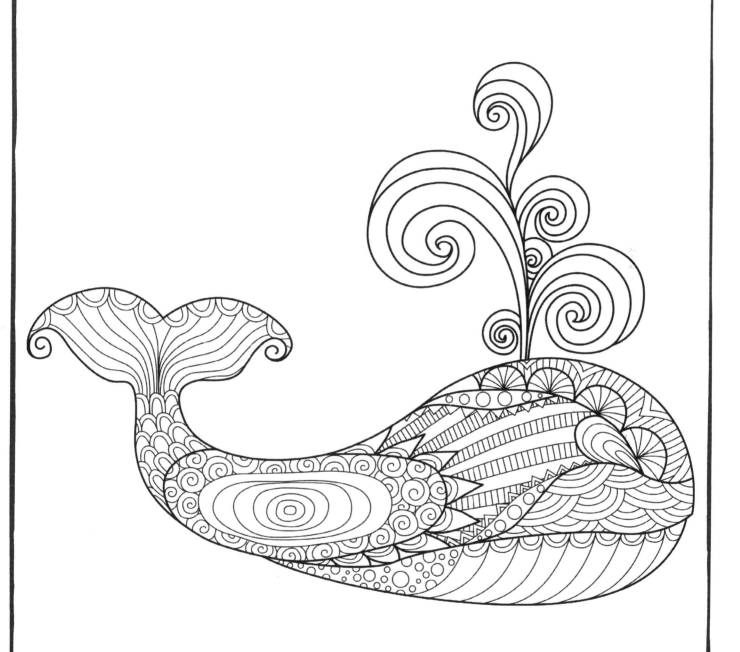

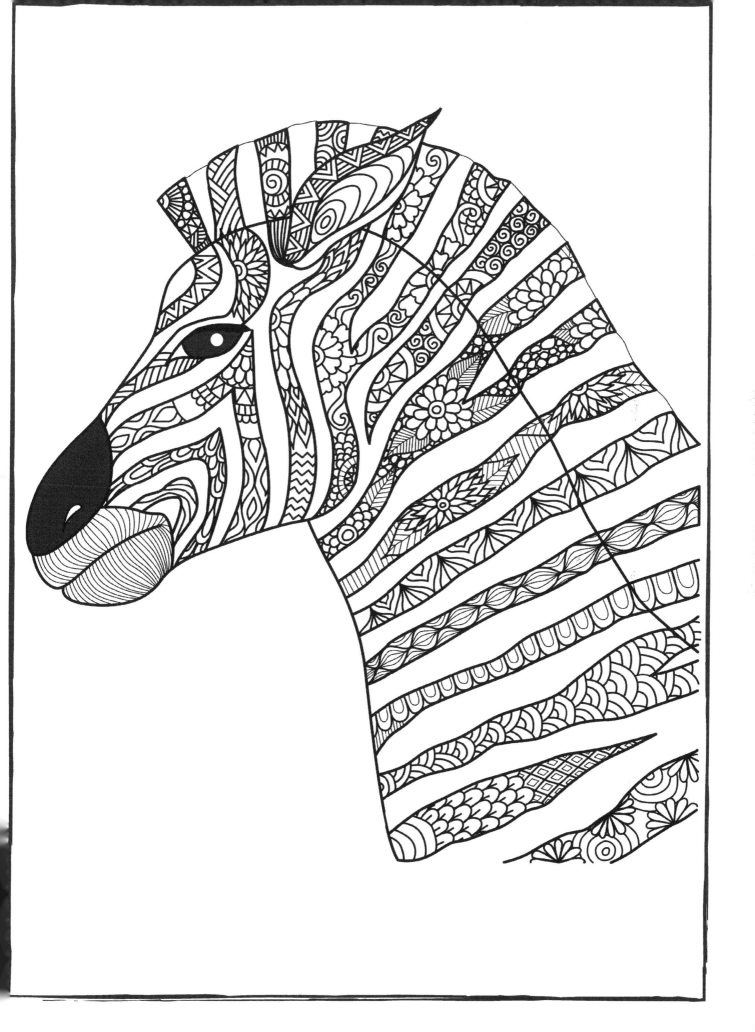

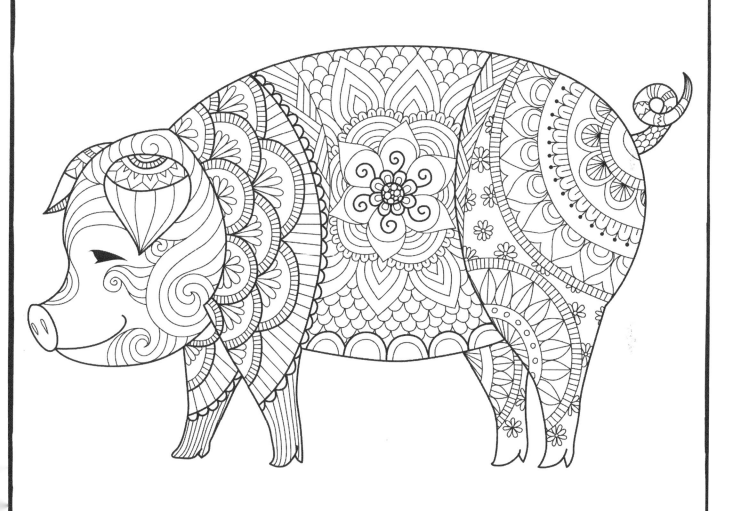

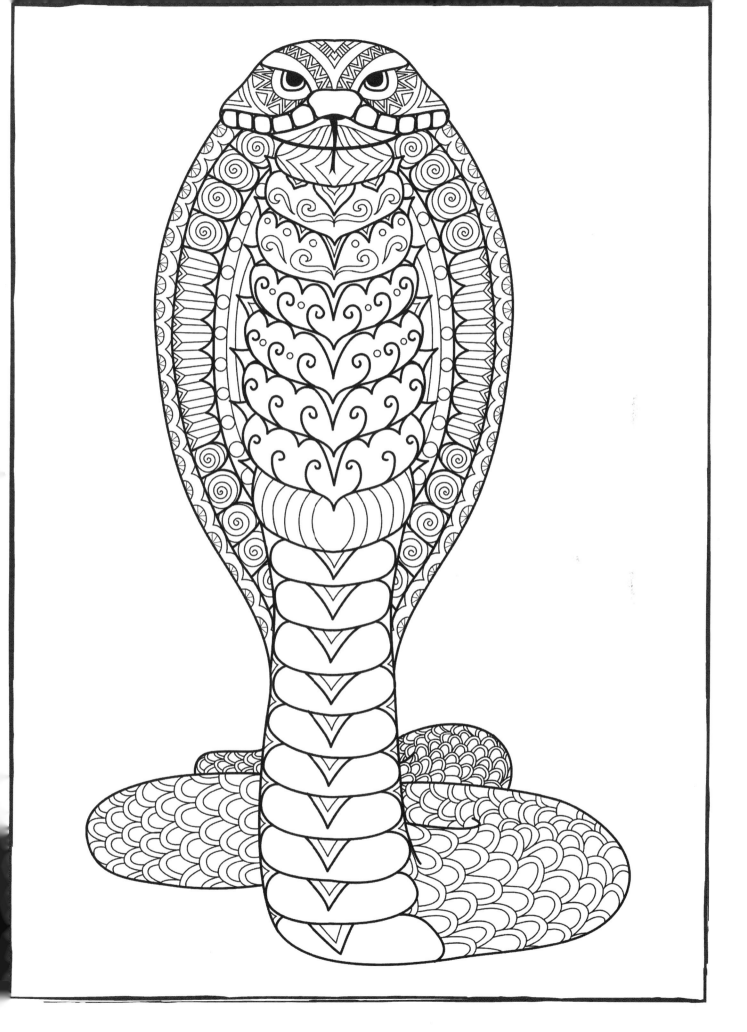

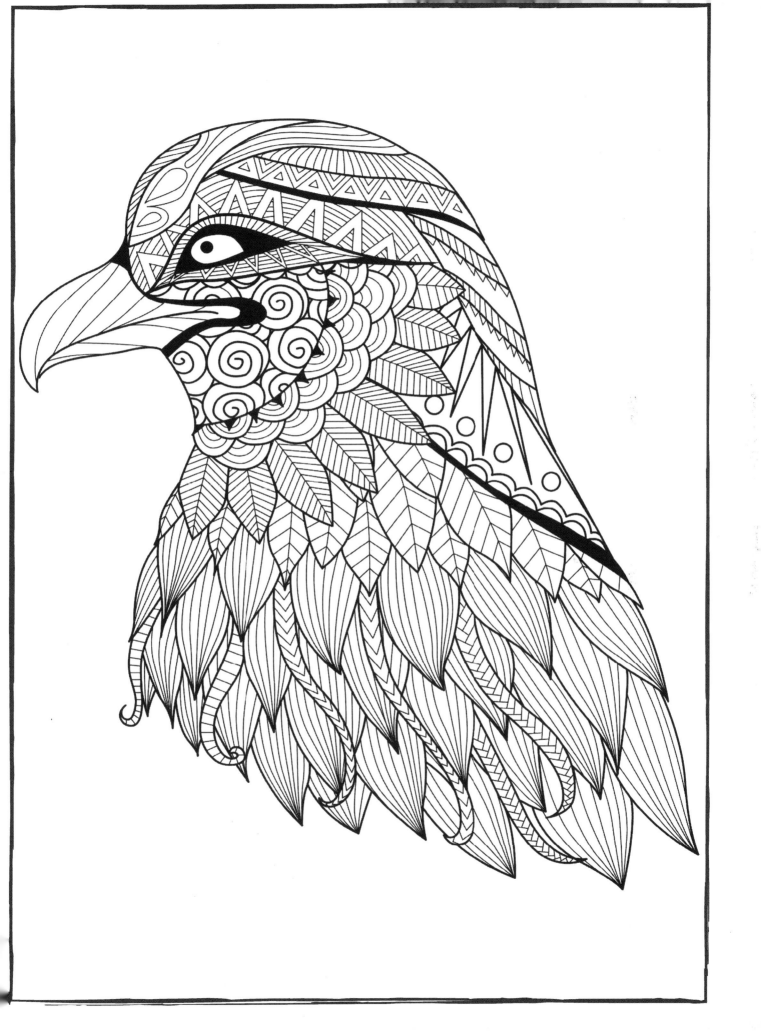

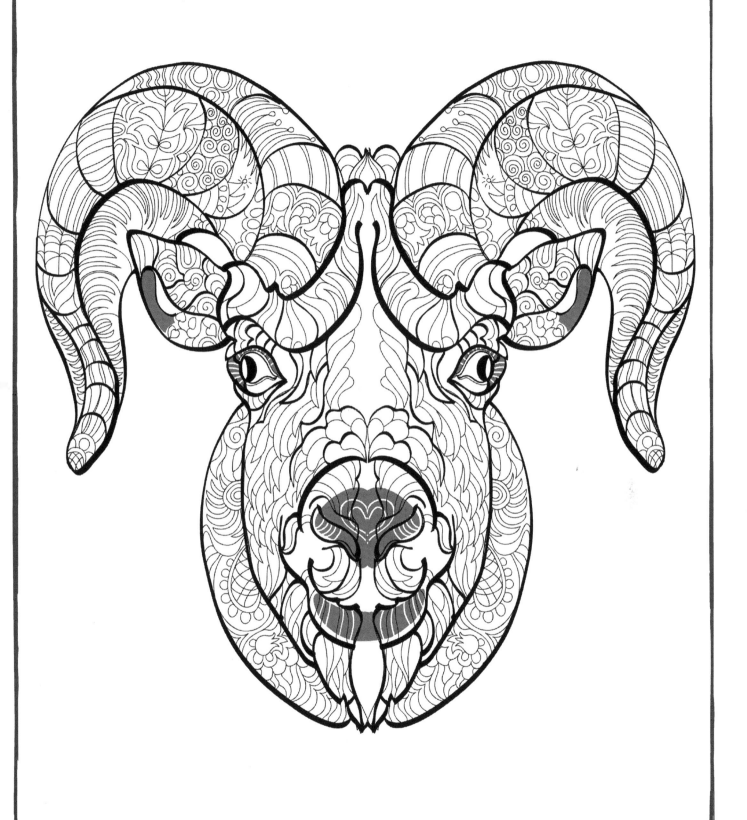

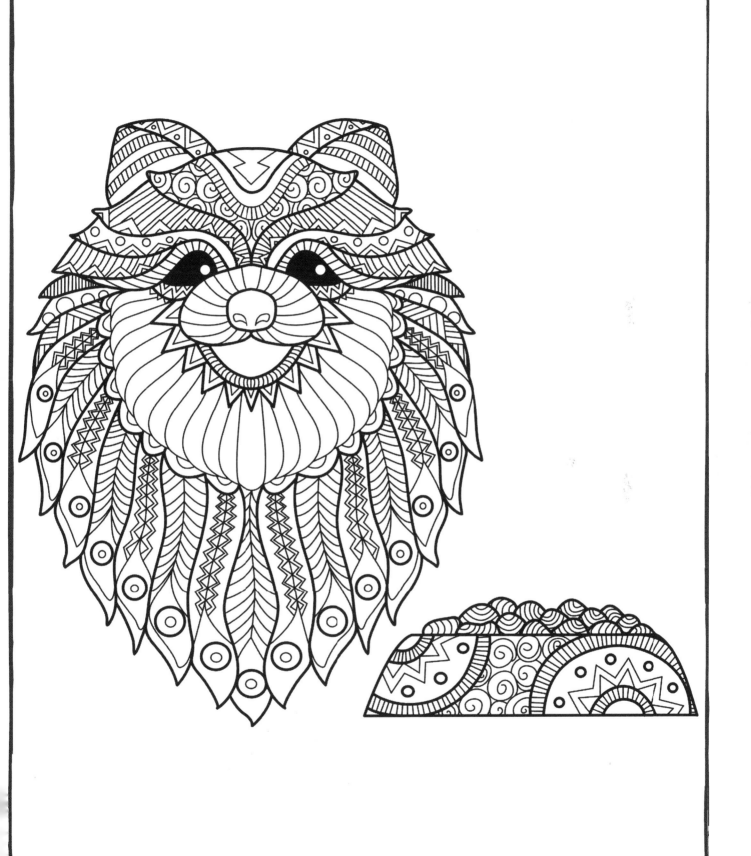

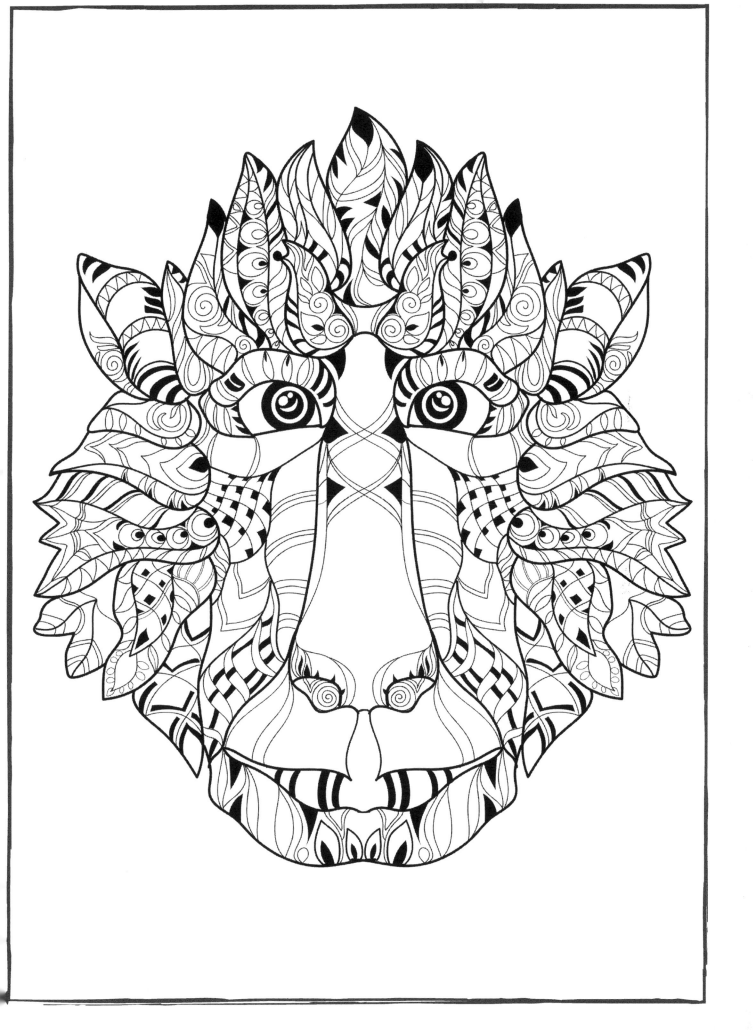

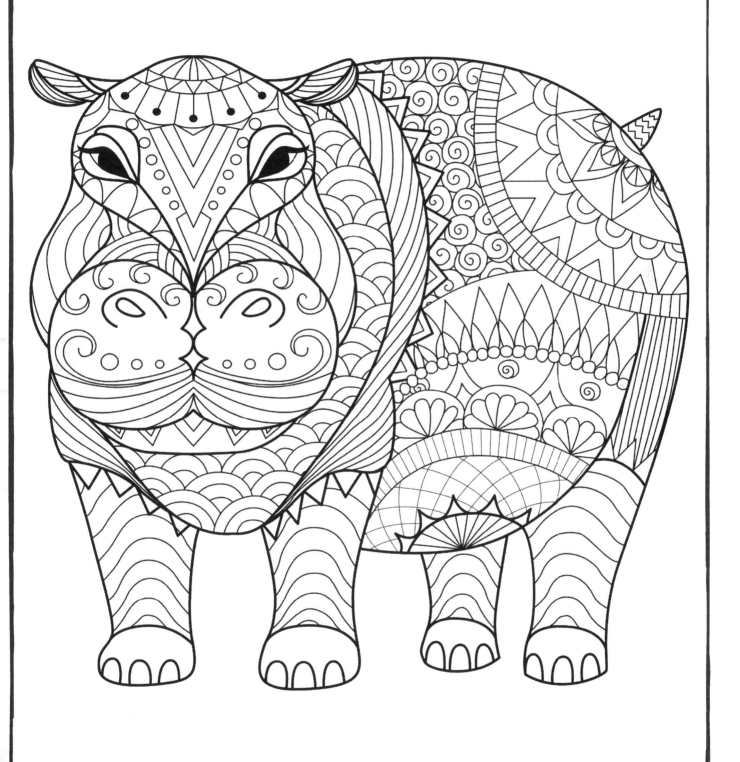

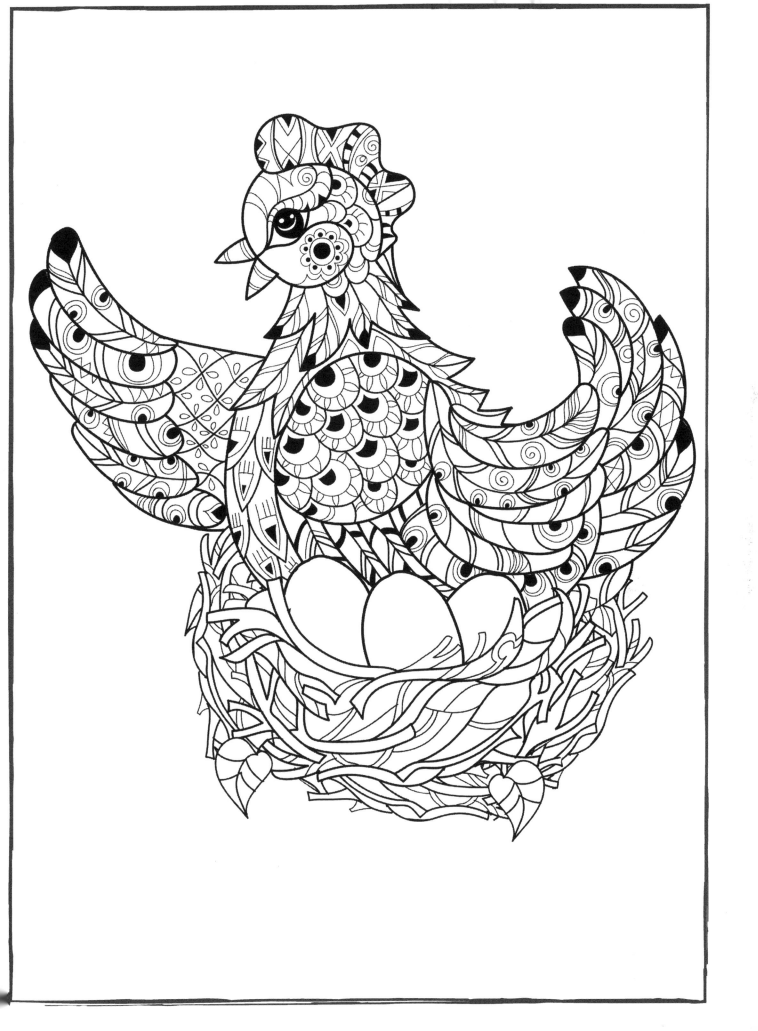

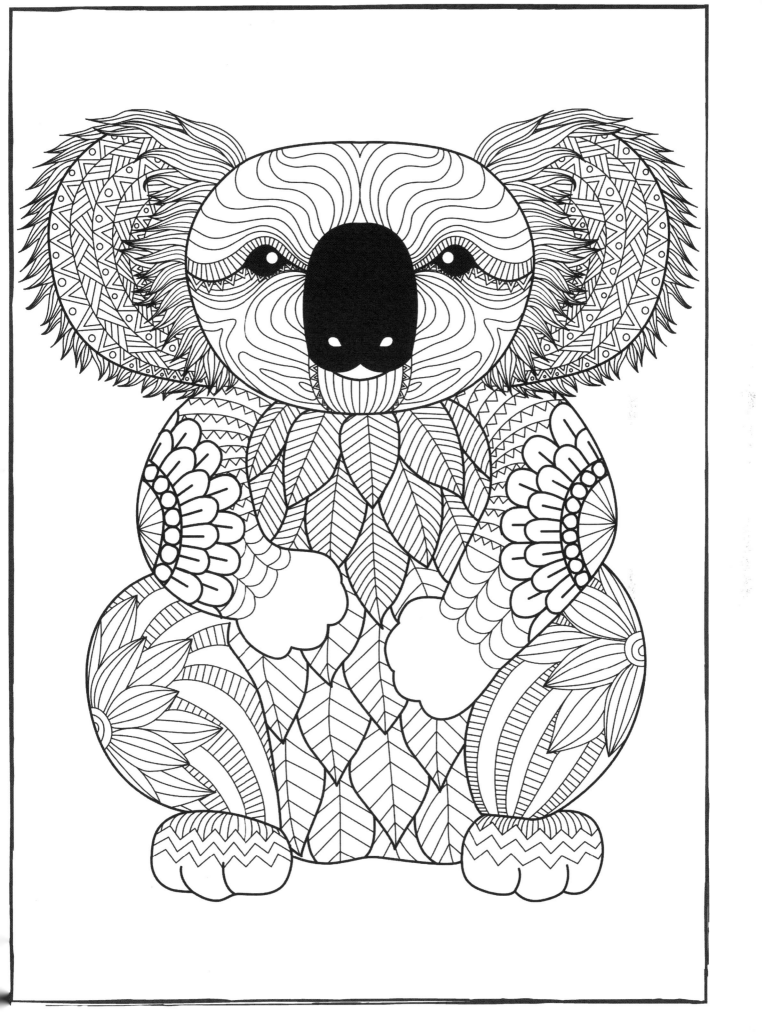

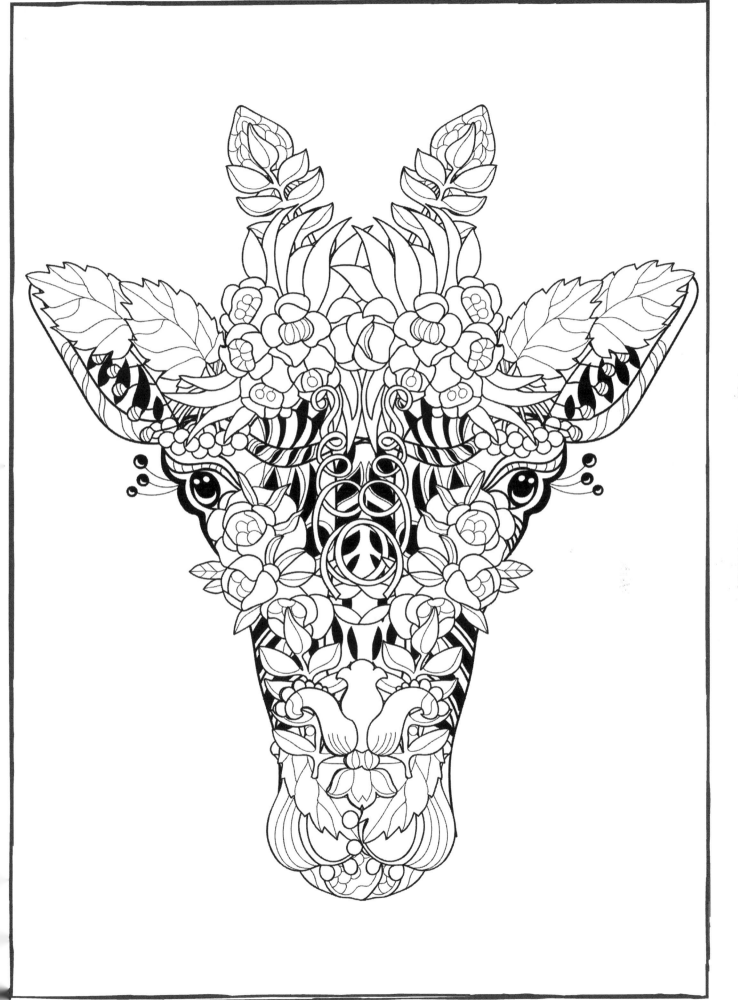

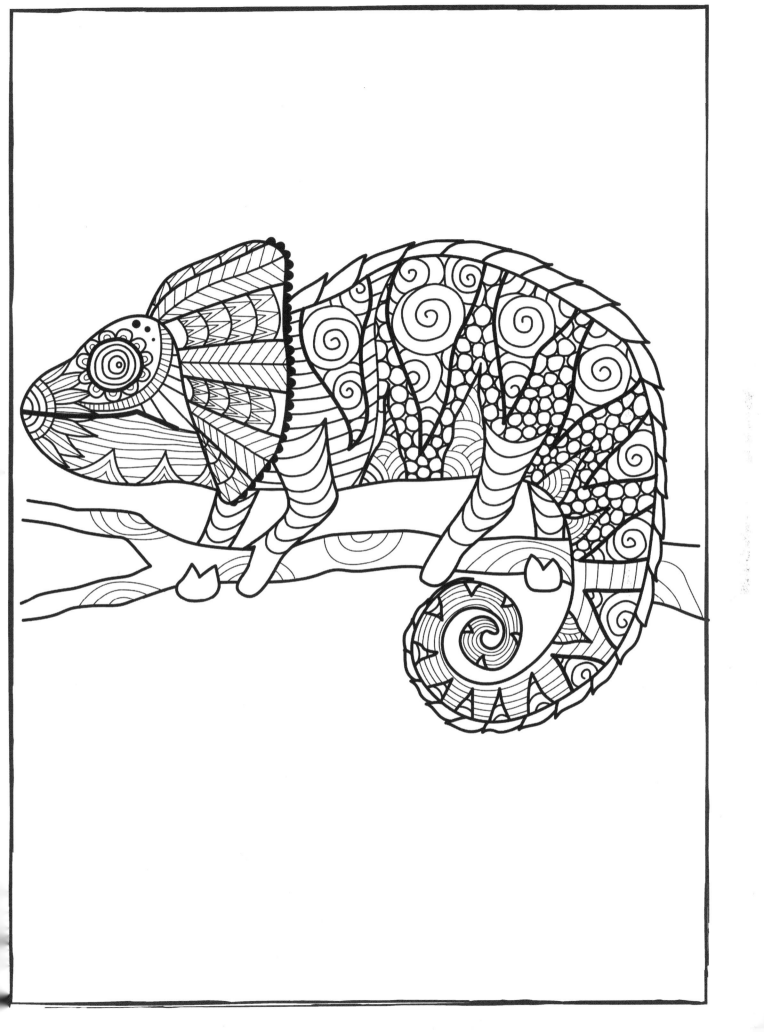

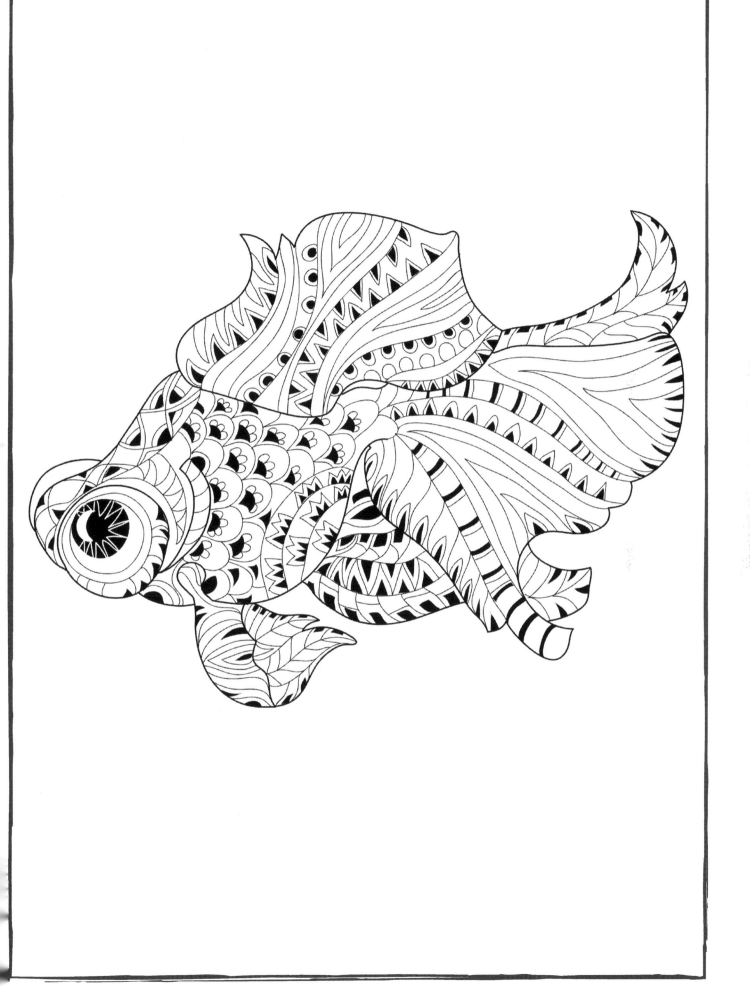

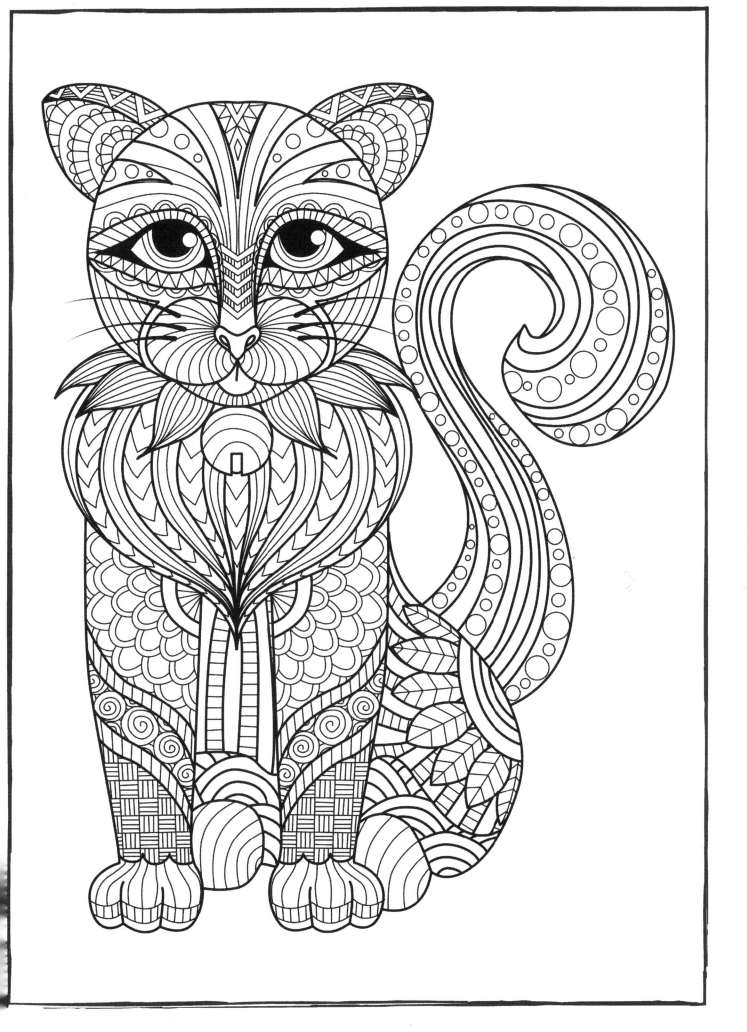

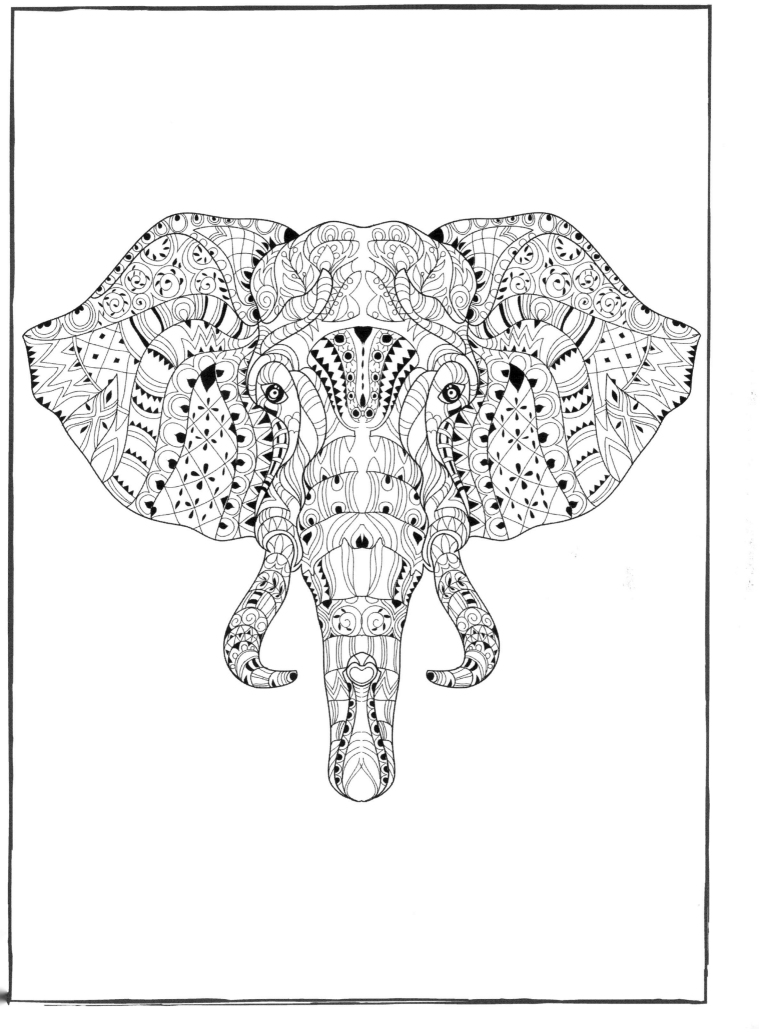

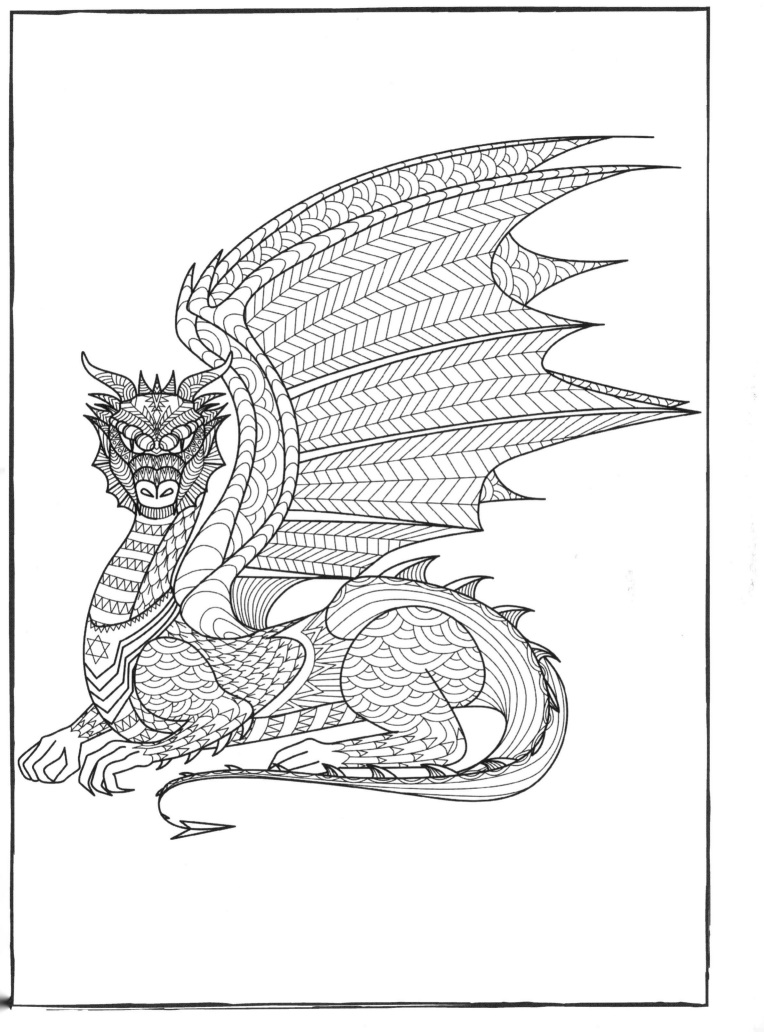

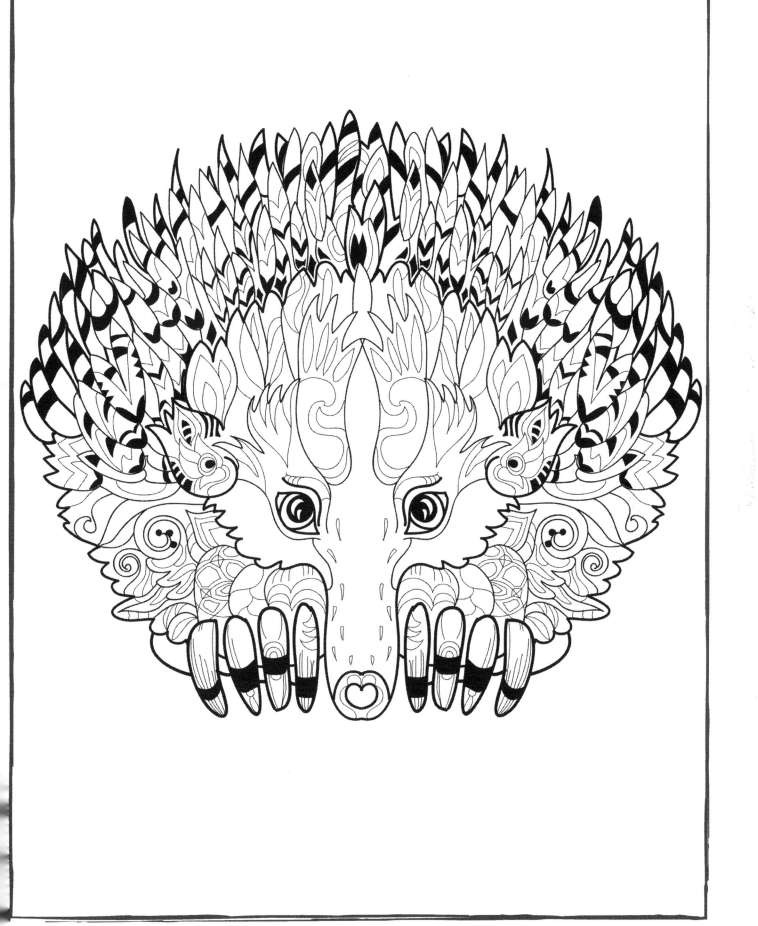

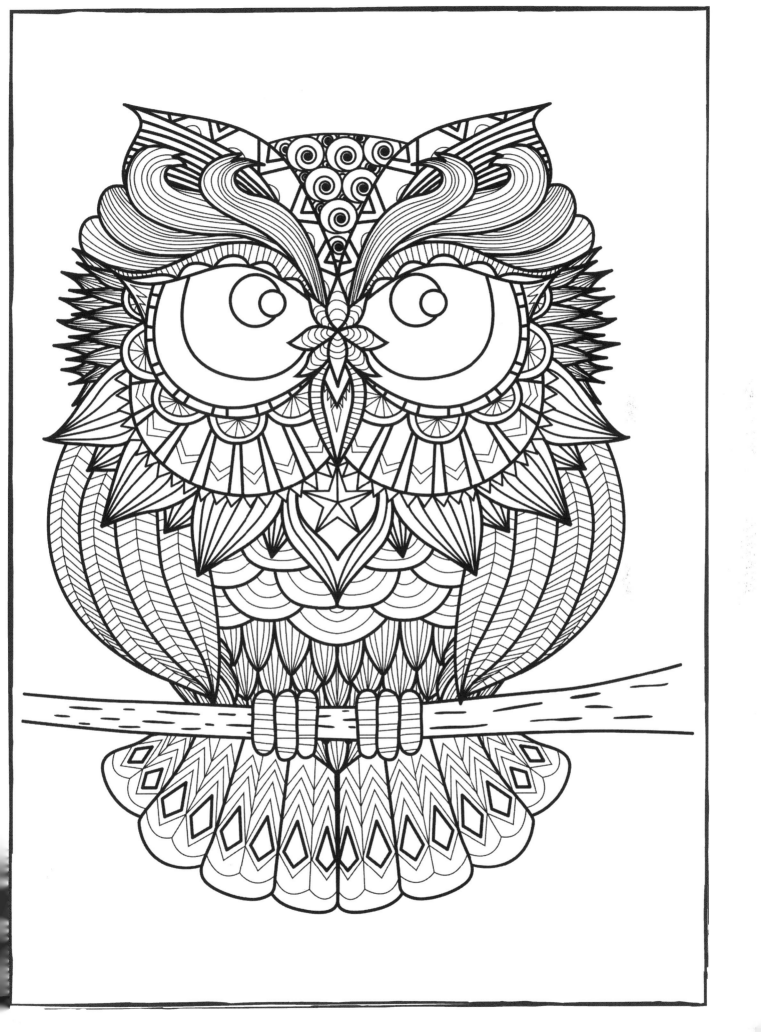

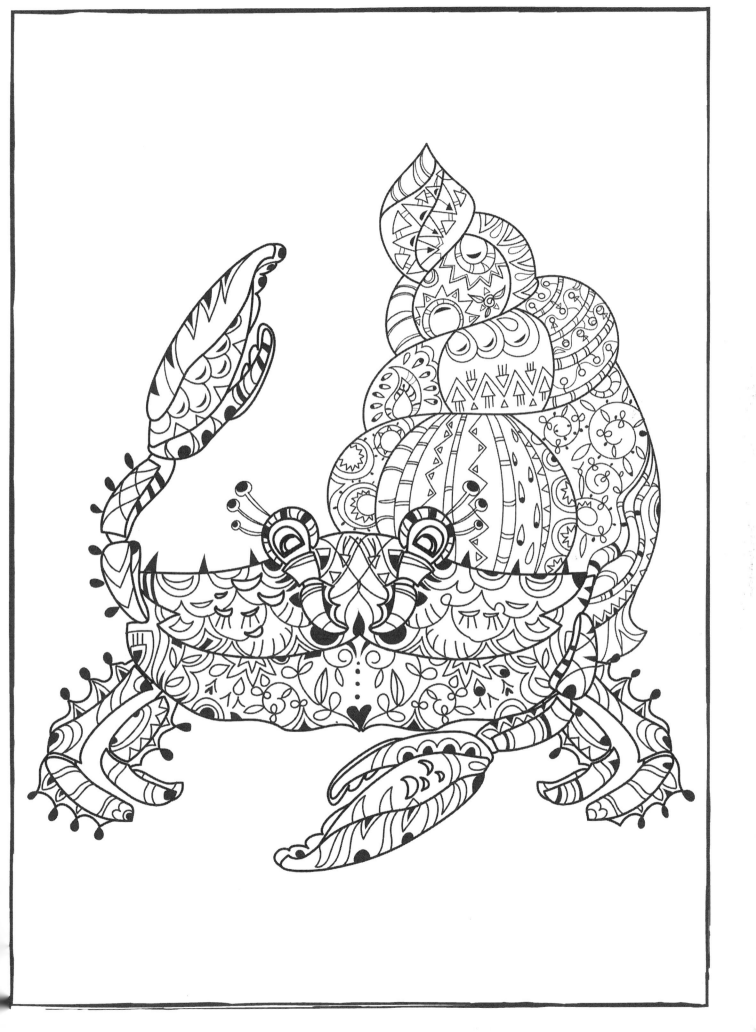

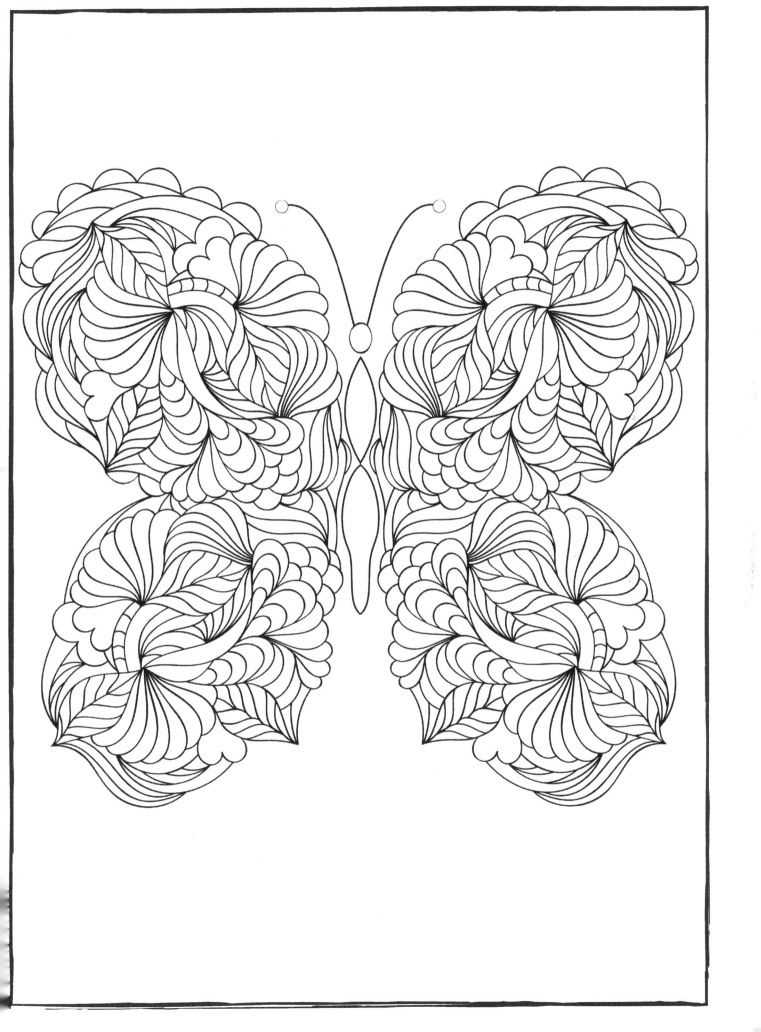

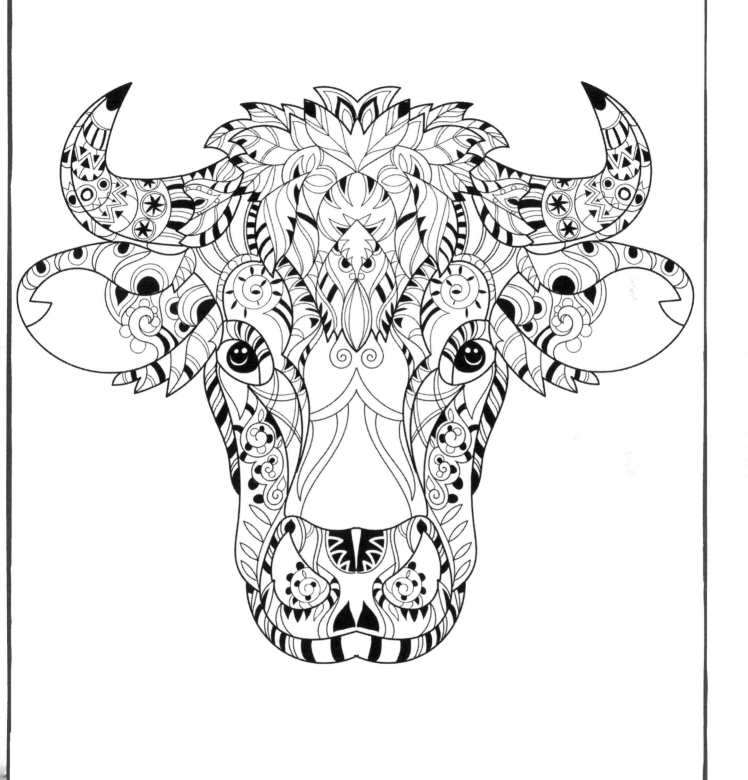

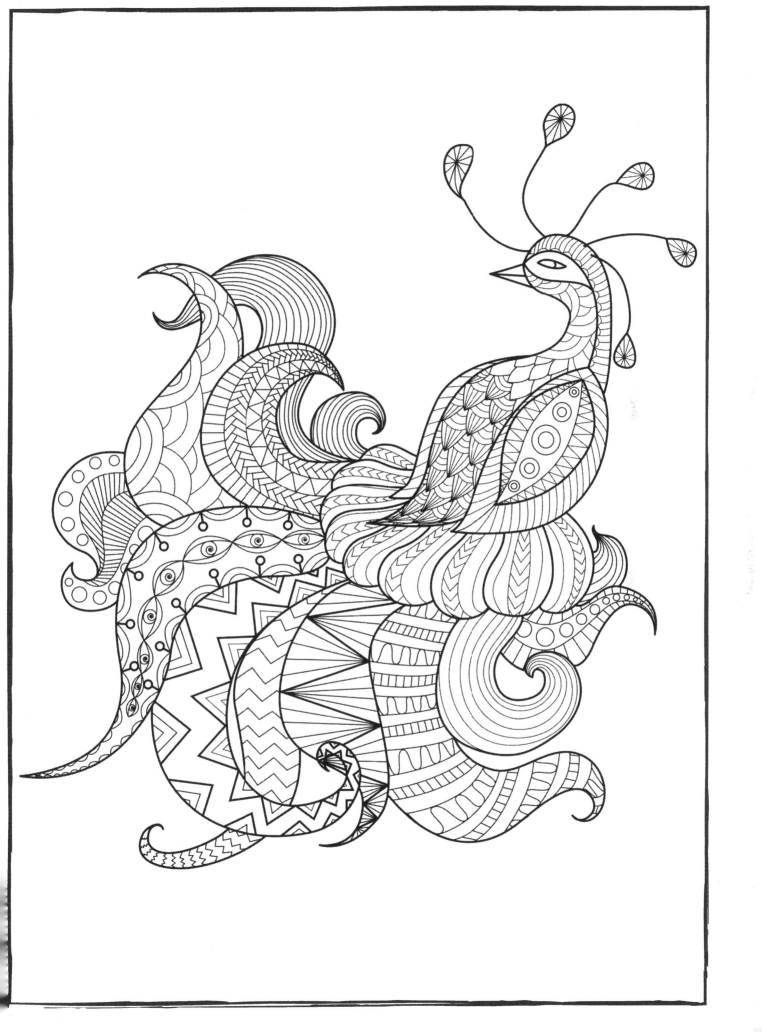

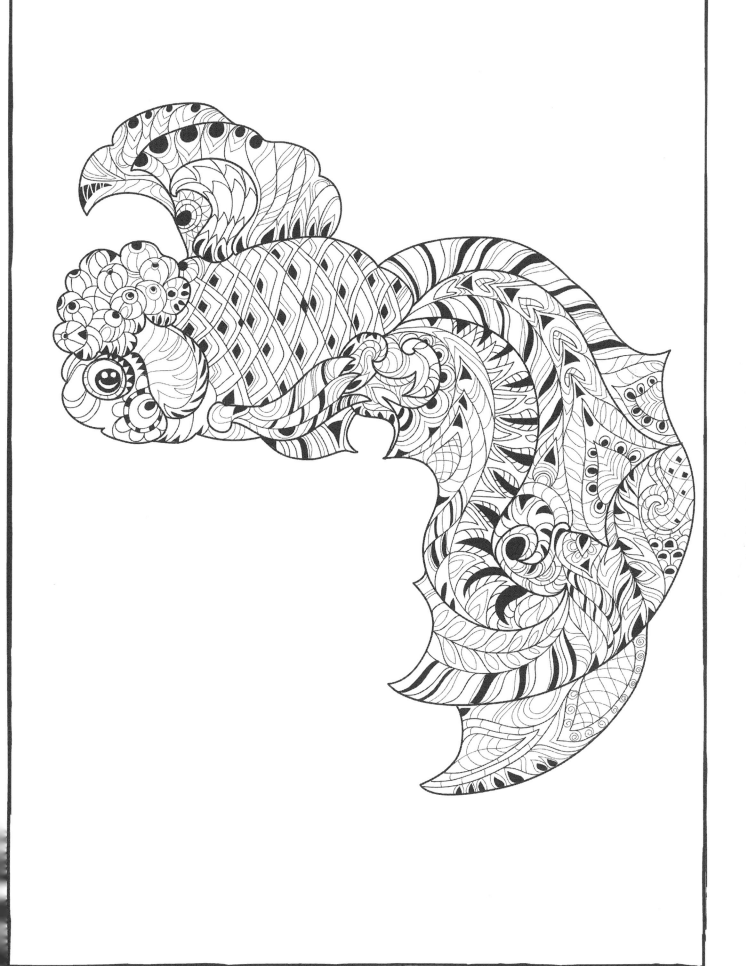

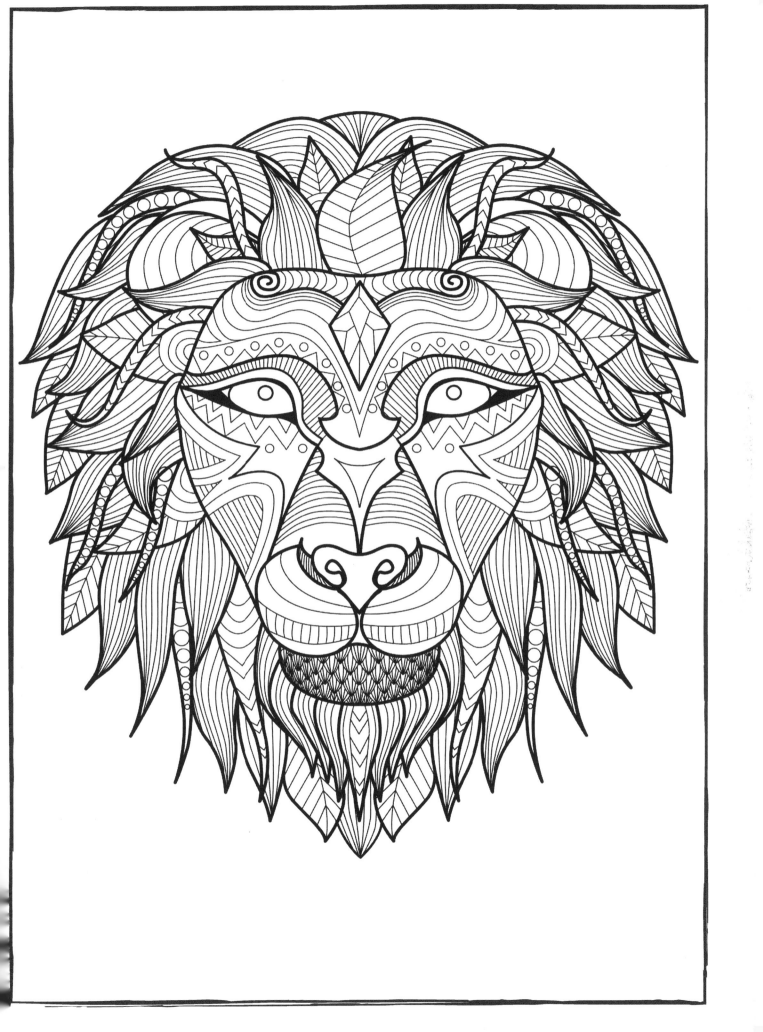

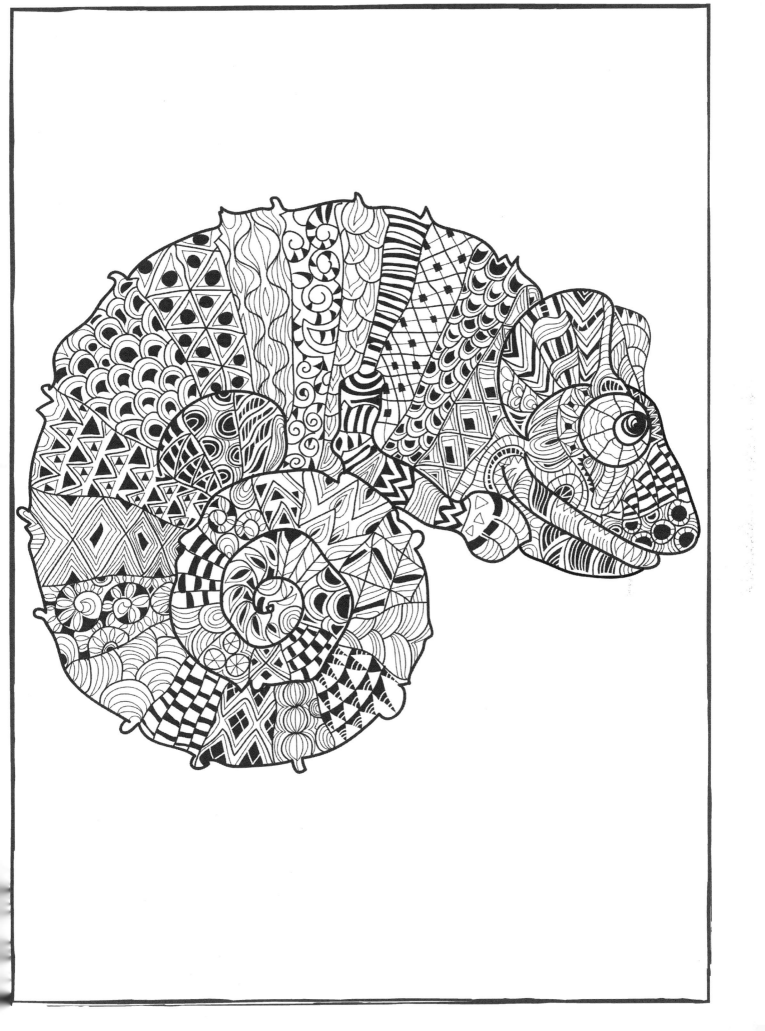

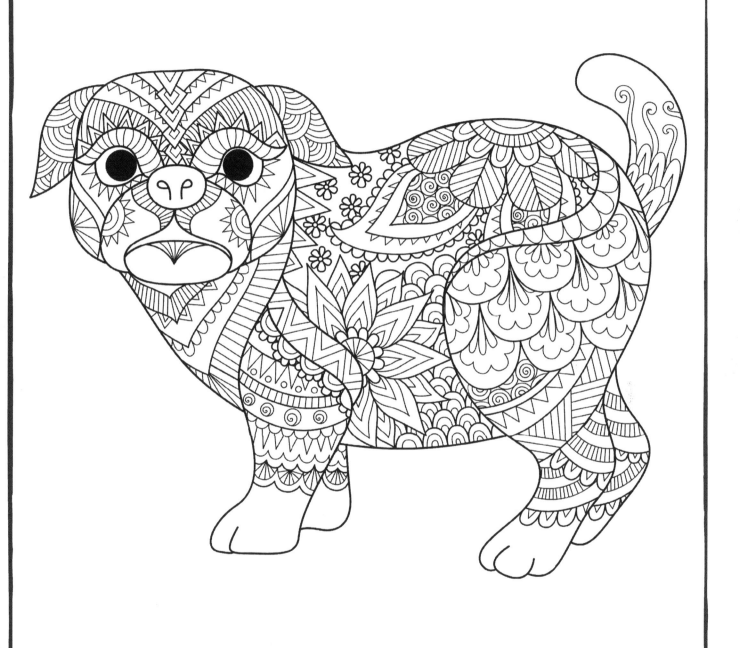

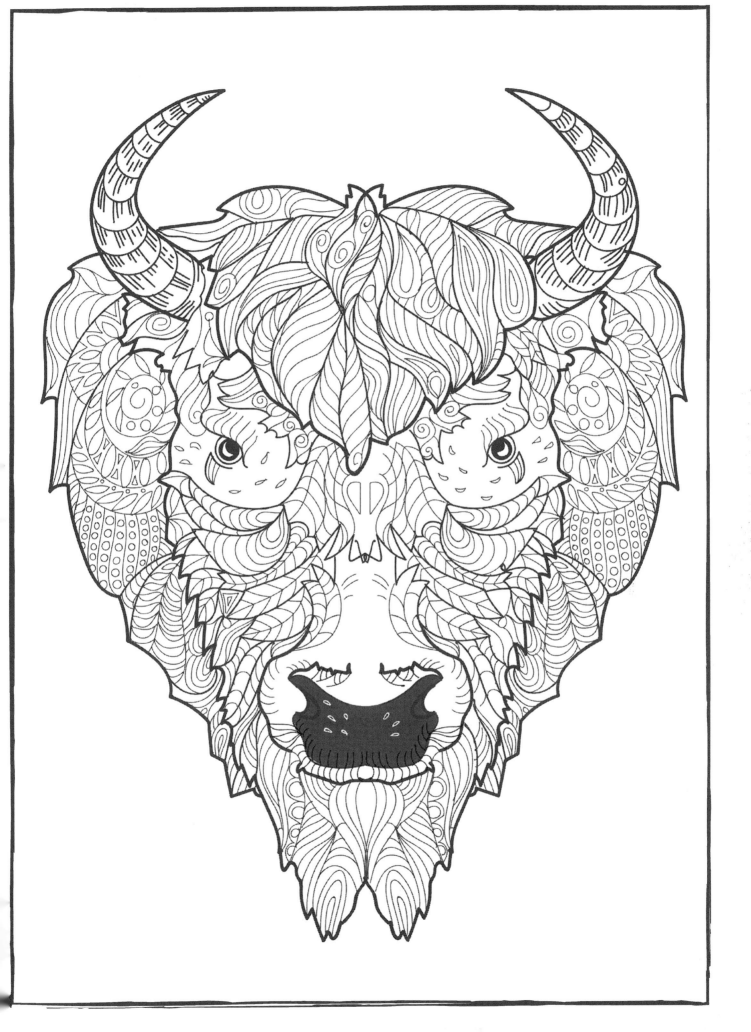

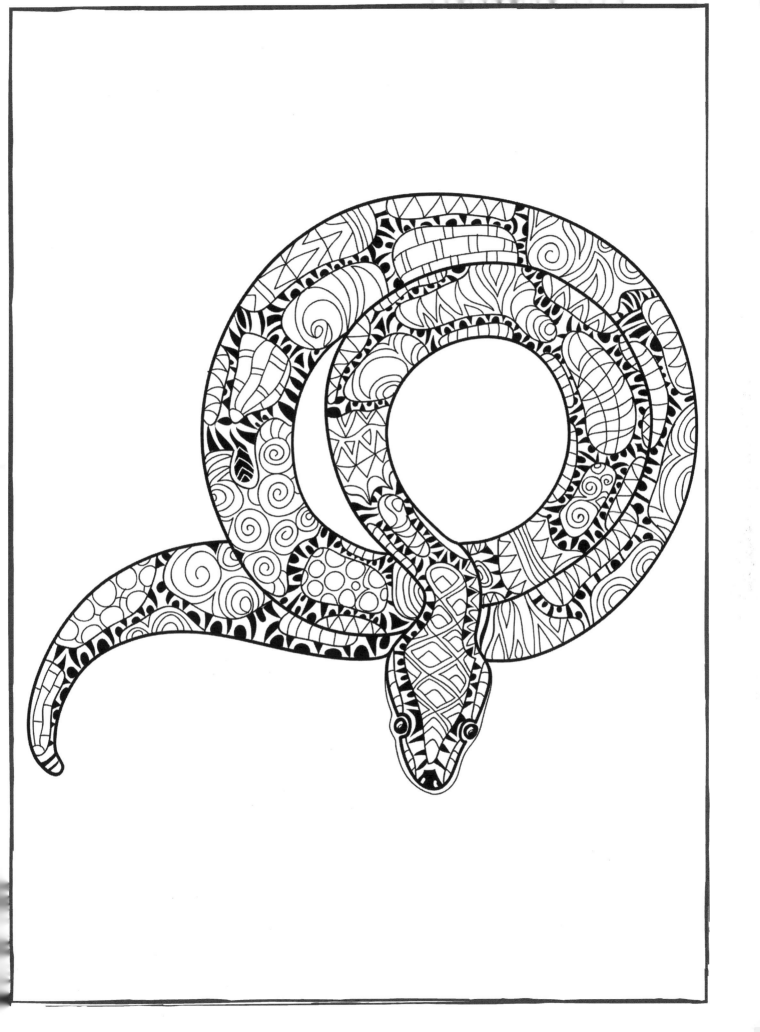

Thank You!

We really hope you enjoyed this book
If so, then please let us know by leaving an Amazon review

Reviews are vital for our business and only take a few seconds to complete. We really appreciate you taking the time to do this.

Also....Please take a moment to browse our author page on amazon for further great colouring books for kids and adults alike

@pollyjenkinspublishing

Facebook.com/PollyJenkins Publishing

Stay in touch

Like us via the links above for news on upcoming releases and offers!

We would love to add your finished work to our social media feeds. Just send them through to our social media feeds, tag us or you can email us at jenkinspolly@outlook.com

50 ANIMALS
AN ADULT COLOURING BOOK

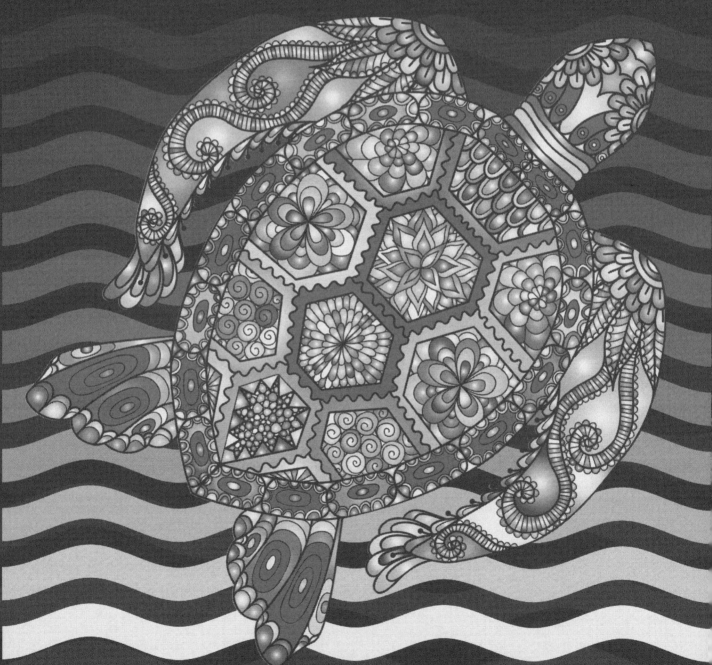

A4 SIZE

Polly Jenkins

Printed in Great Britain
by Amazon